Geometric Patterns
Circles + Squares

Carolyn Gramlich

Copyright © 2017 by Carolyn Gramlich

All rights reserved. No part of this publication may be reproduced, distributed, or transmitted in any form or by any means, including photocopying, recording, or other electronic or mechanical methods, without the prior written permission of the author.

Dedication
For Cat, Darren and Stephen
for teaching me to believe in myself.

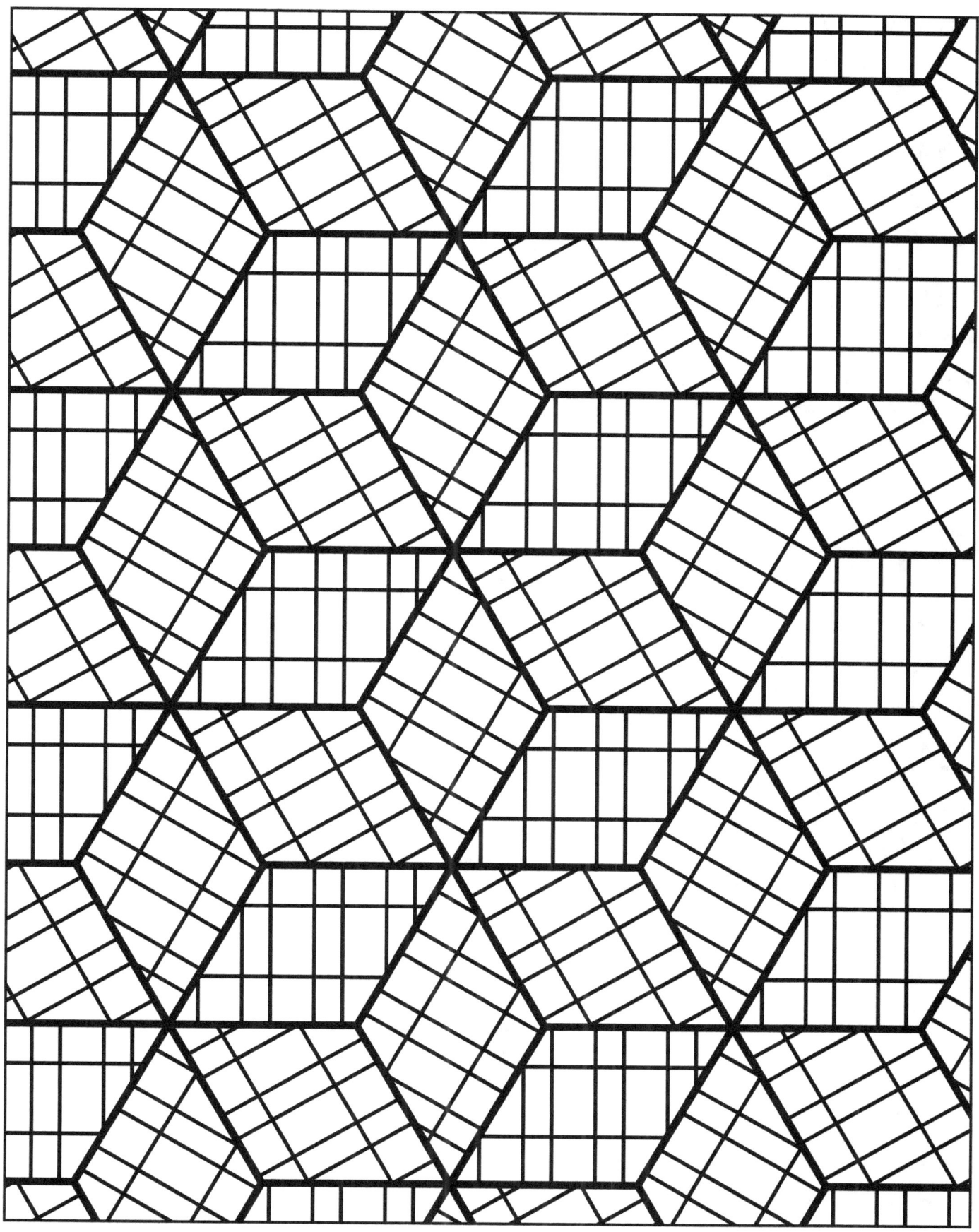

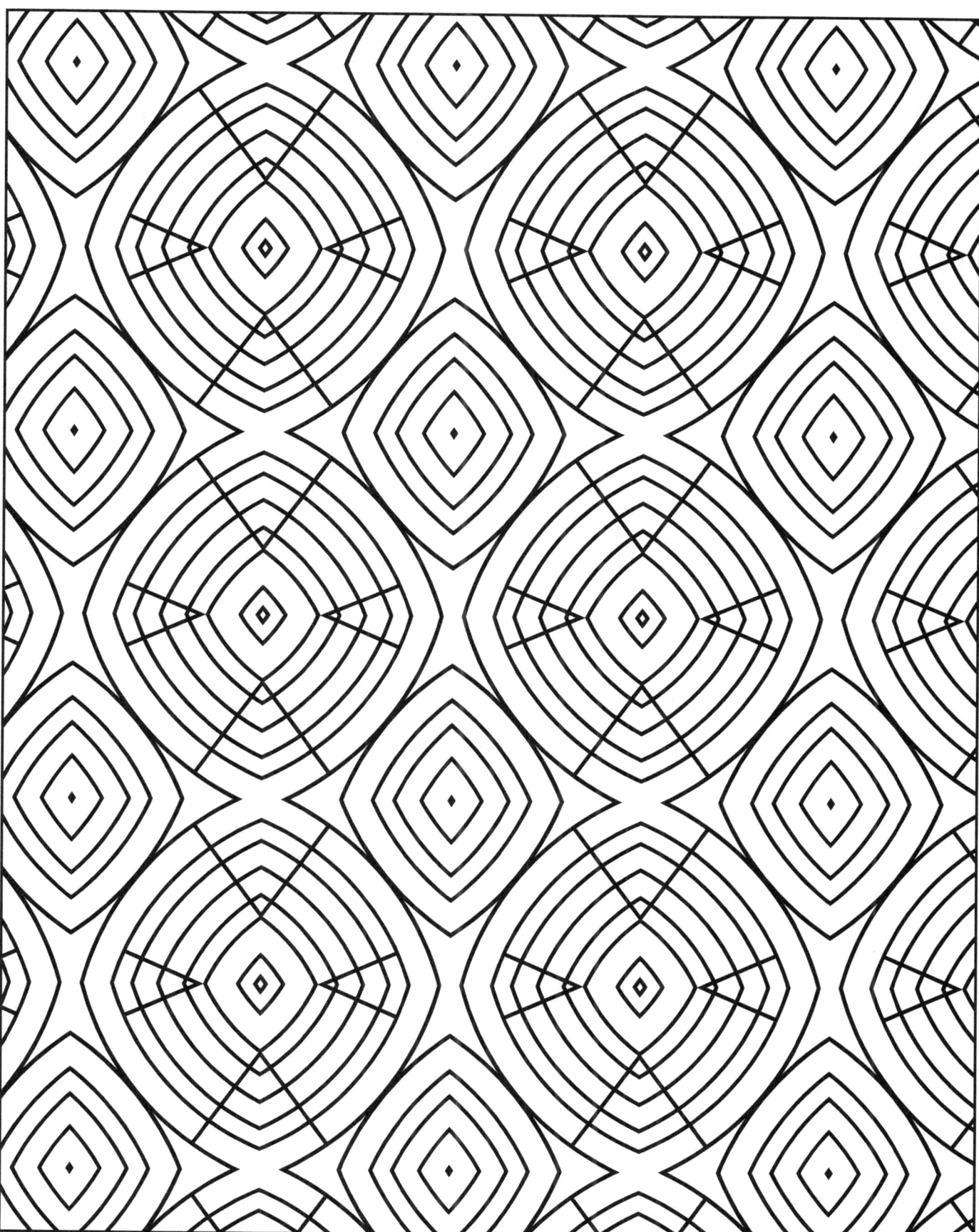

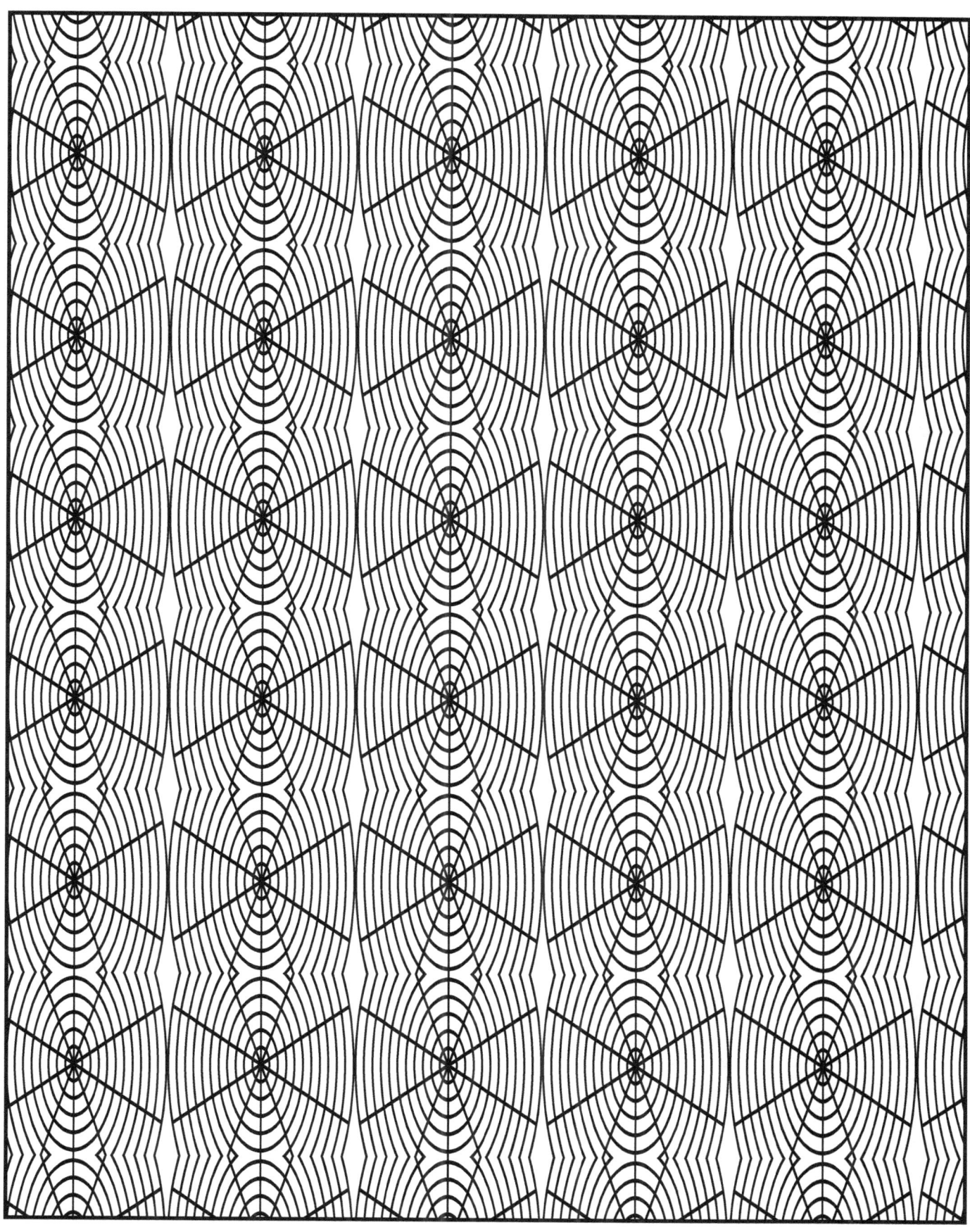

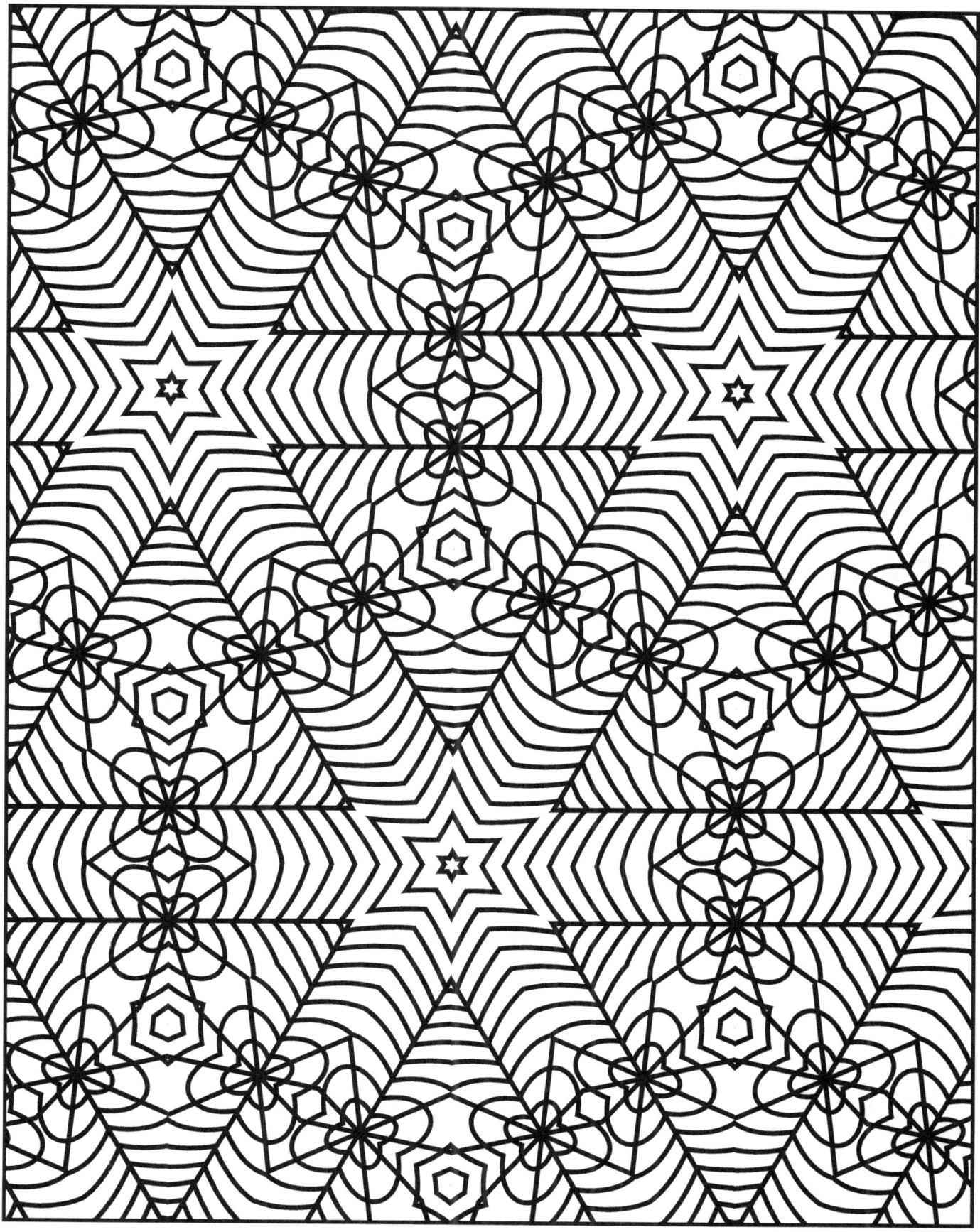

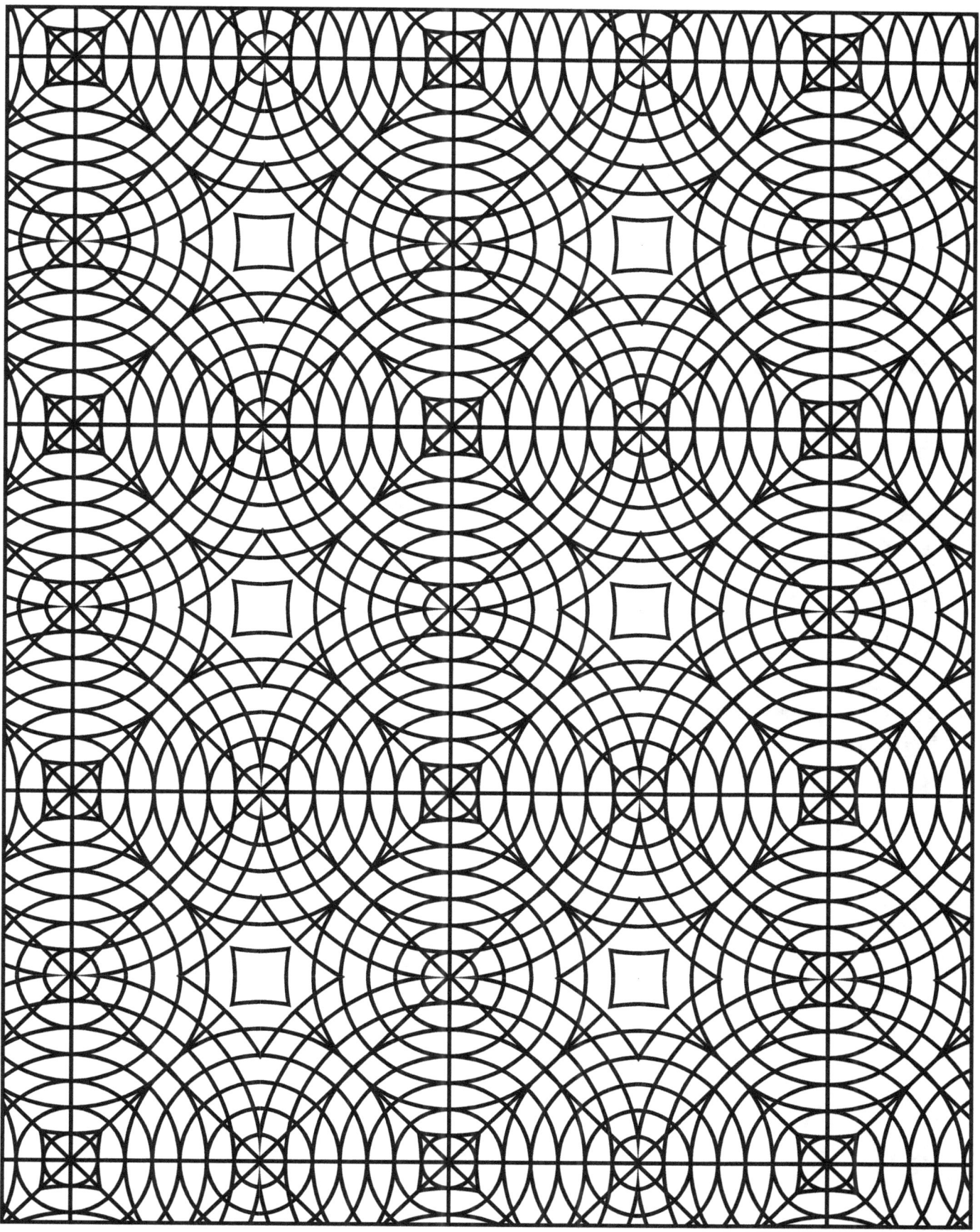

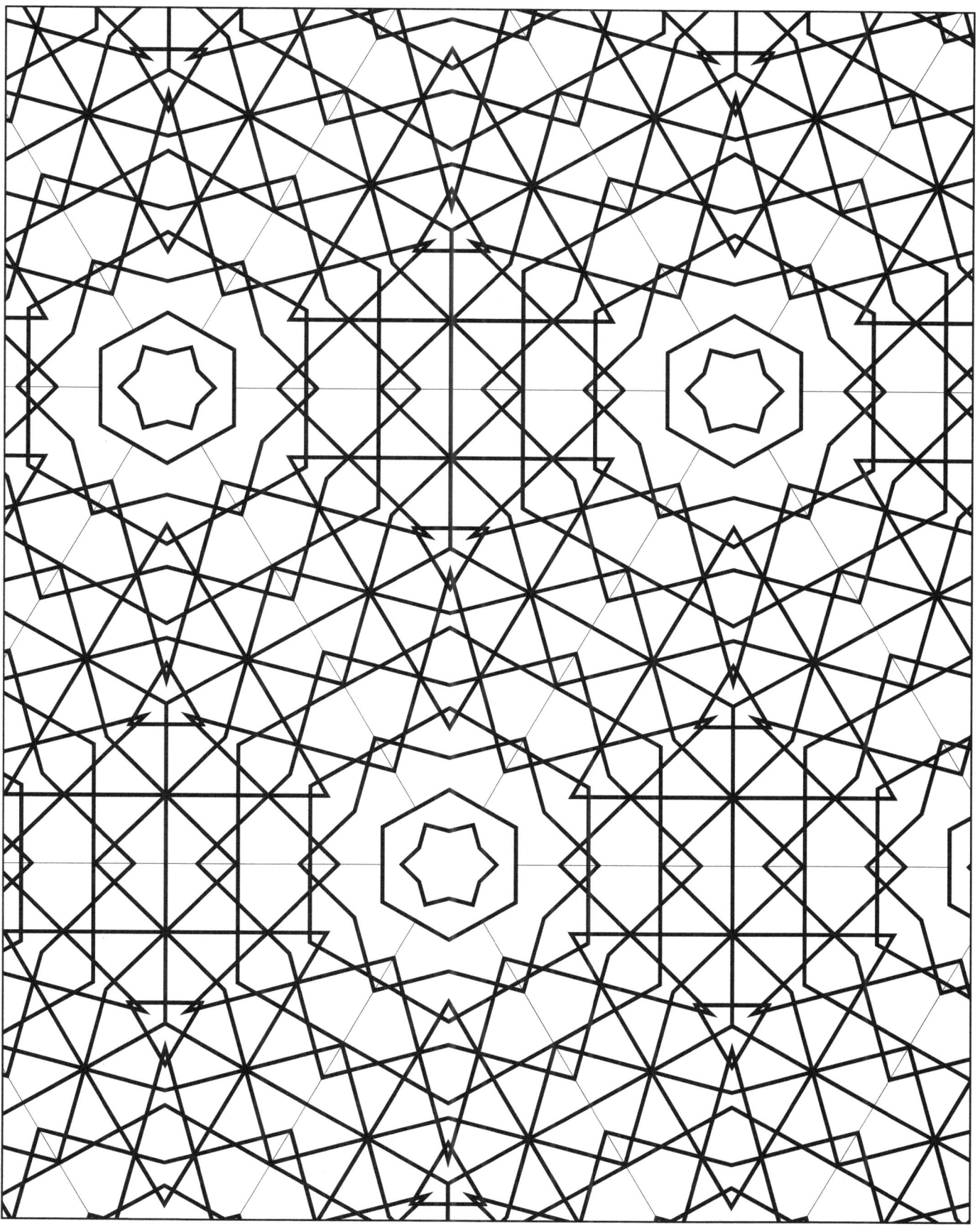

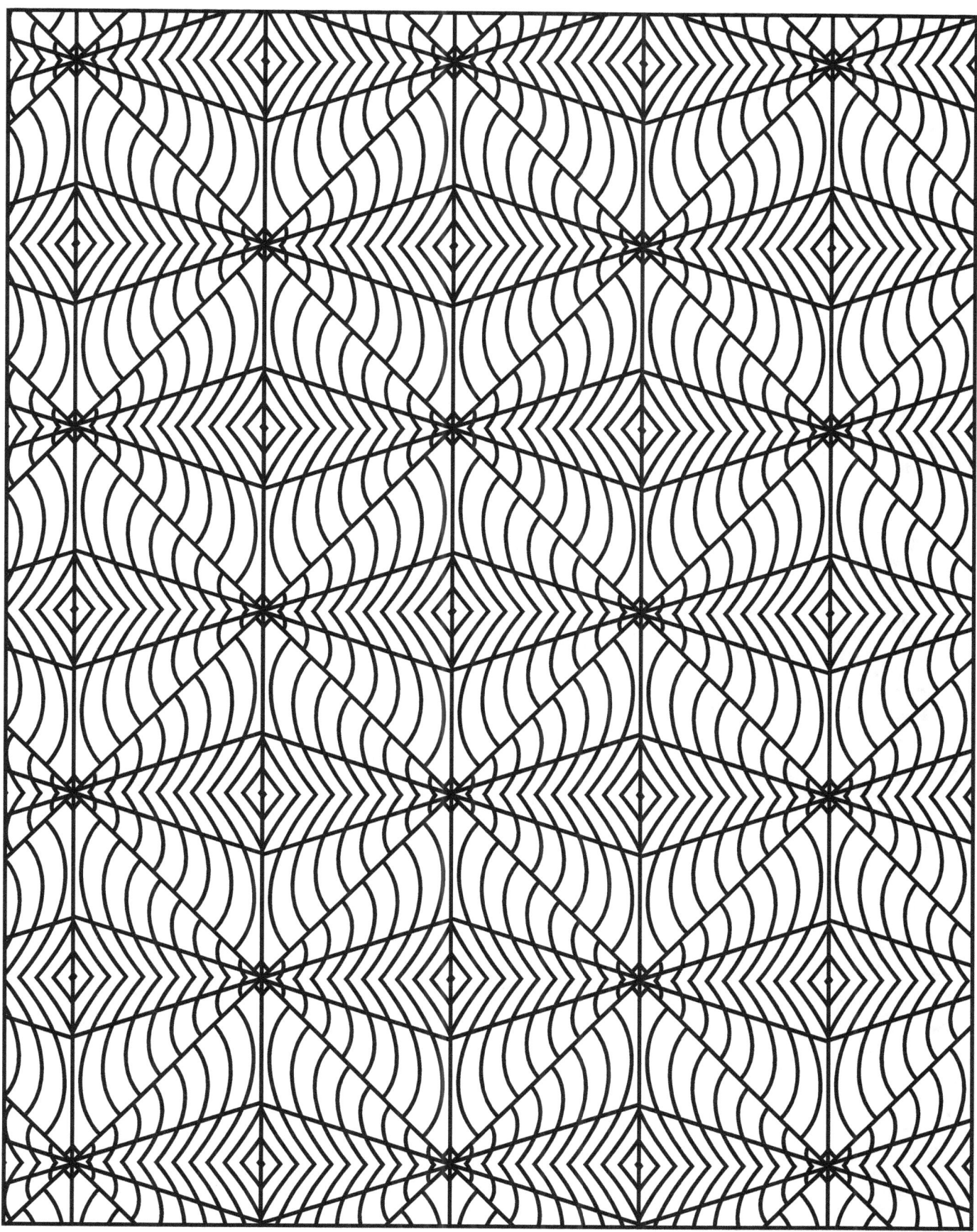

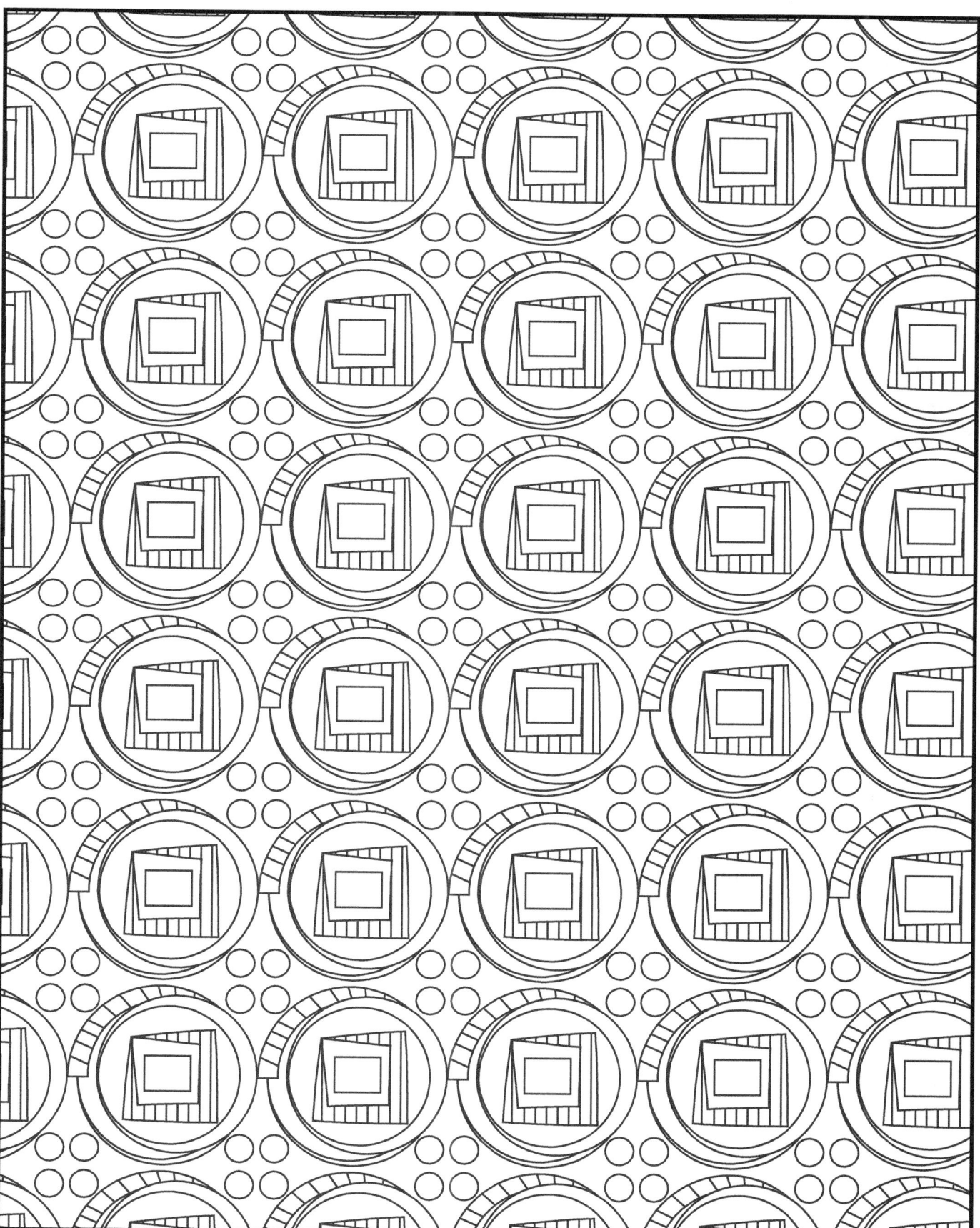

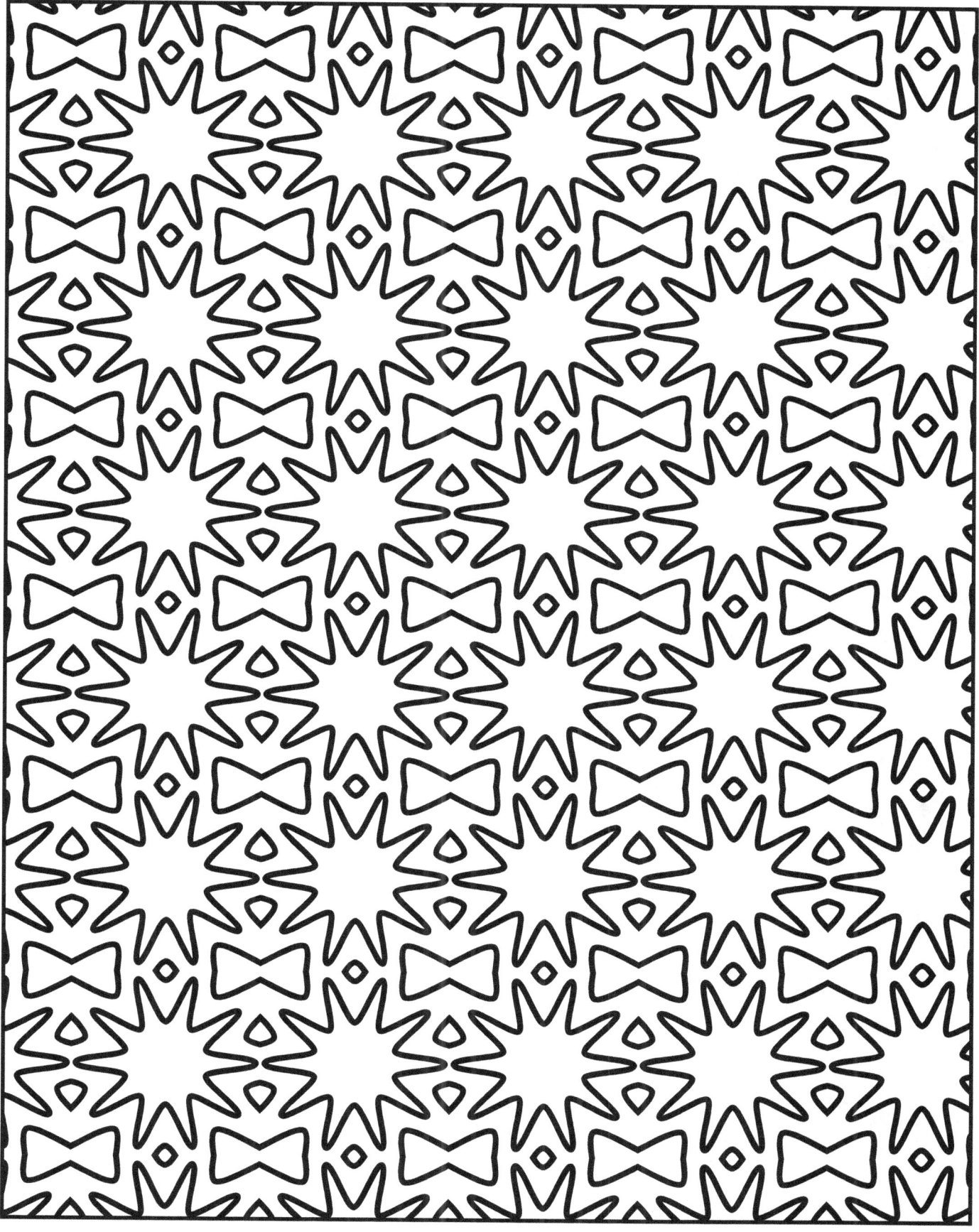

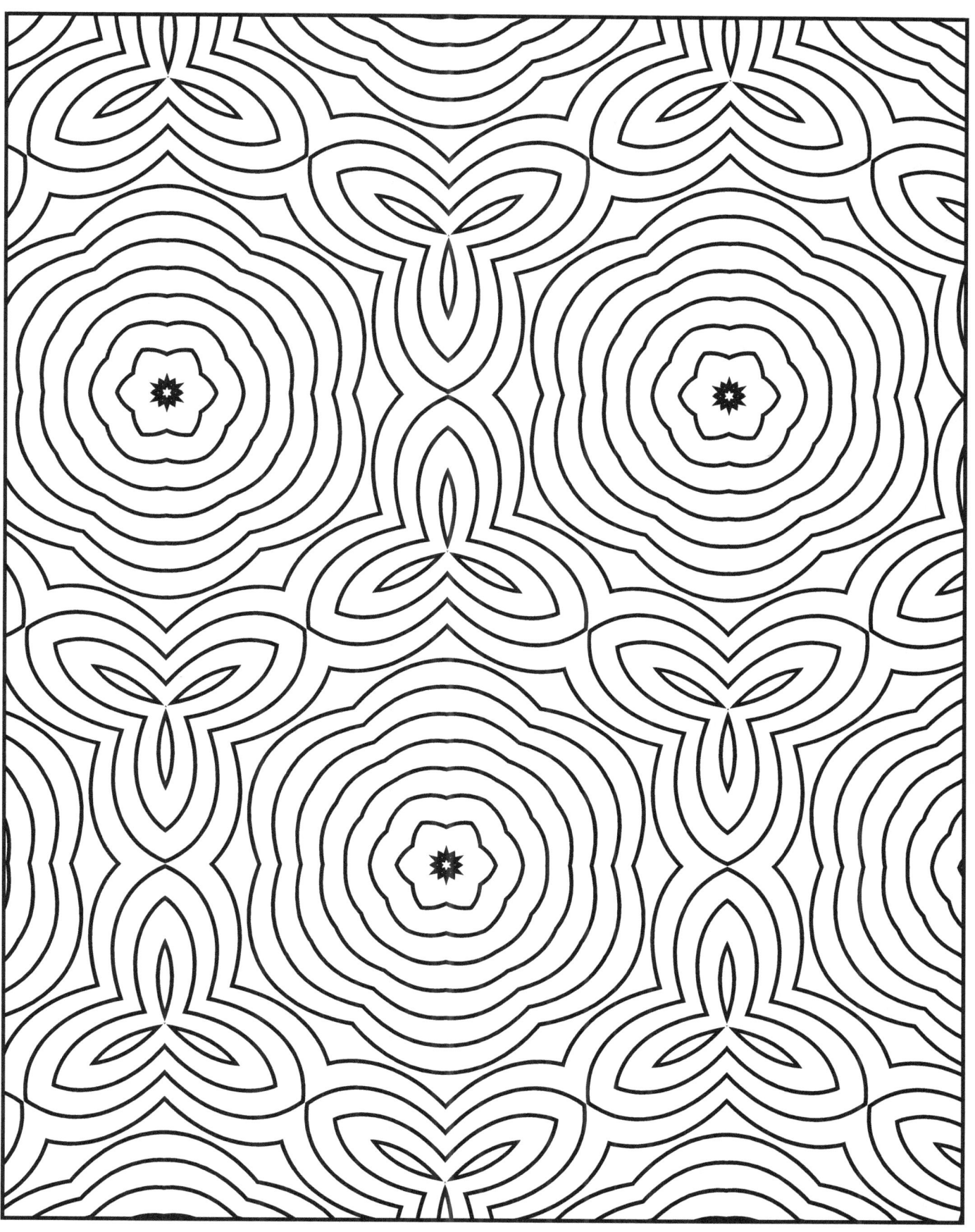

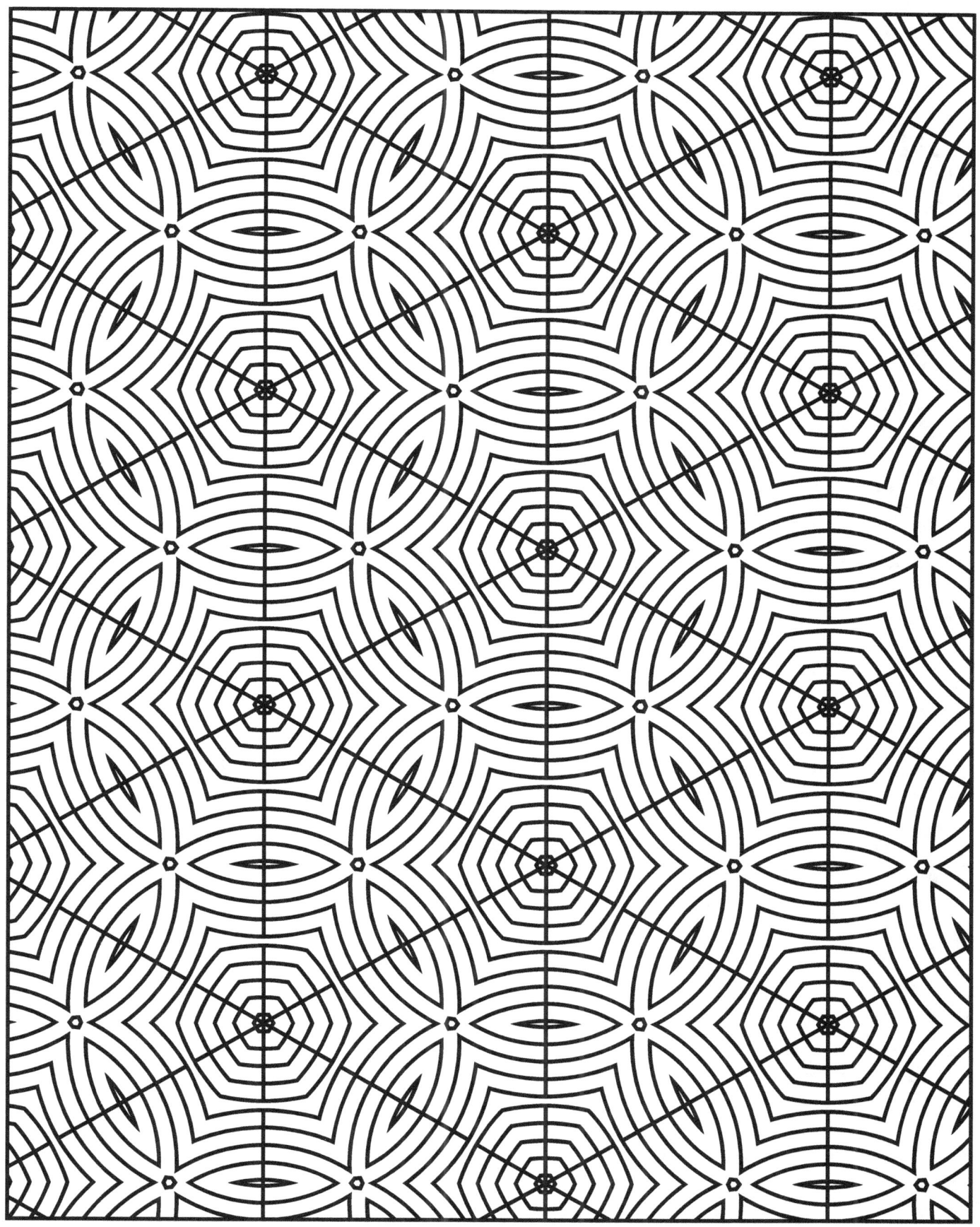

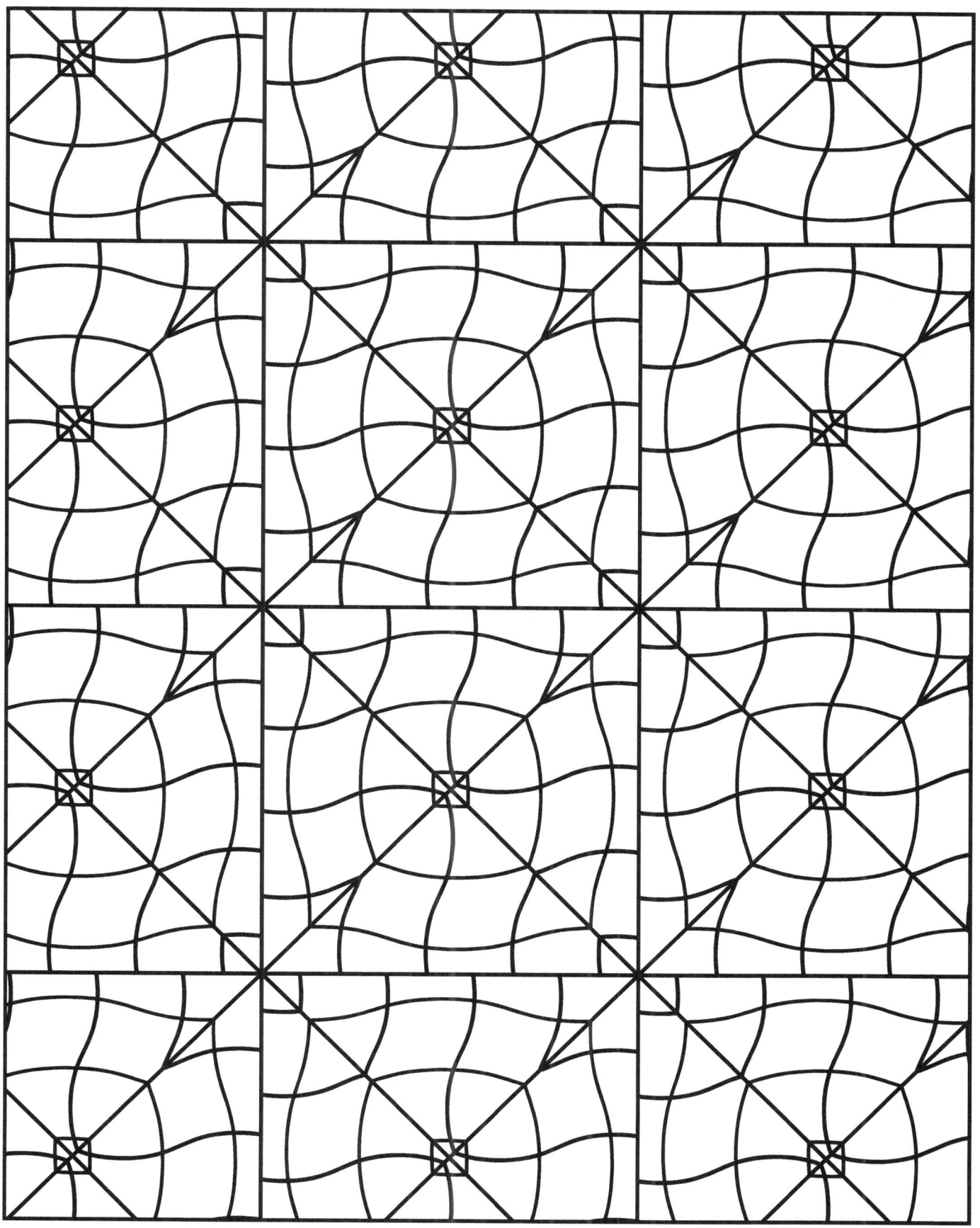

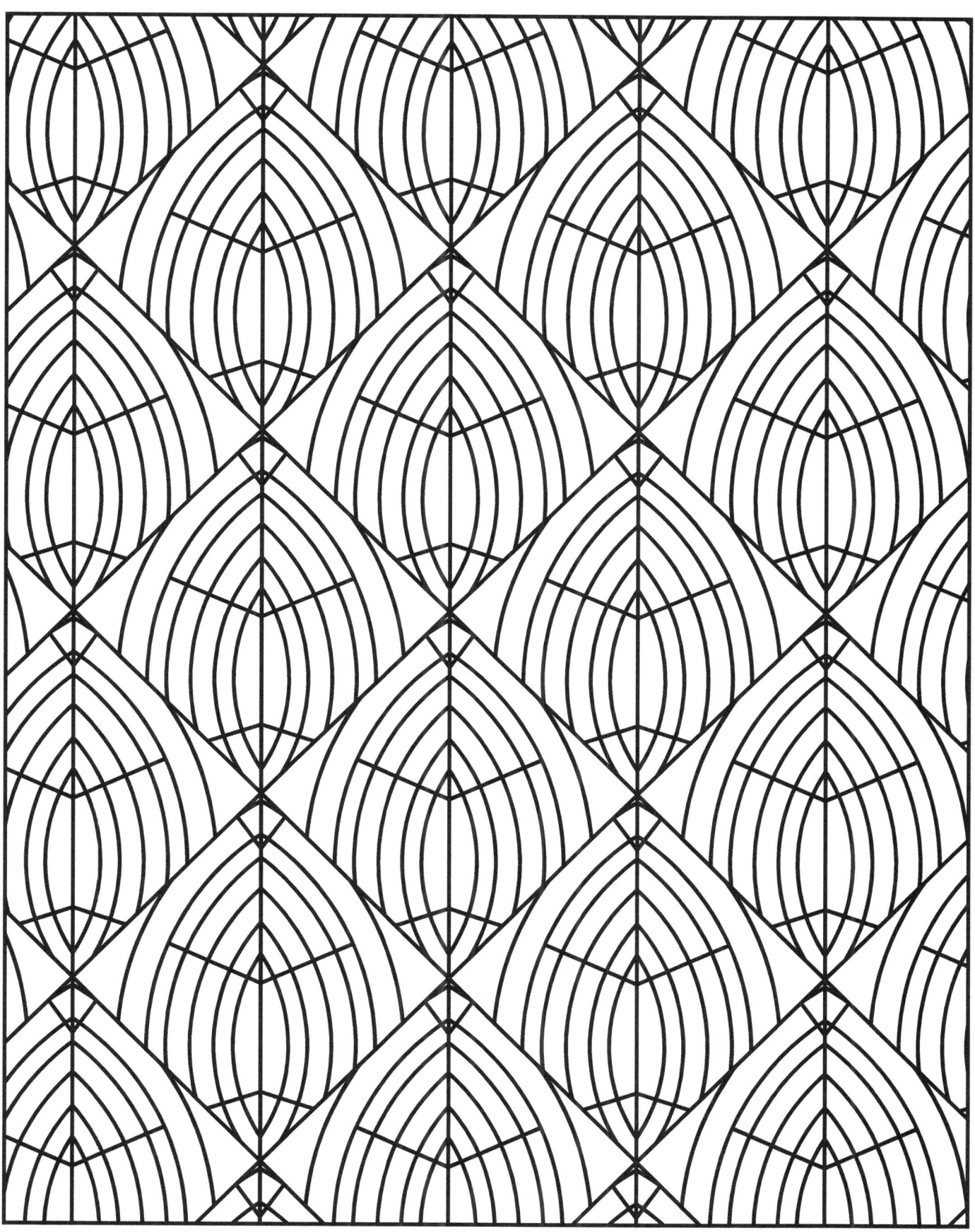

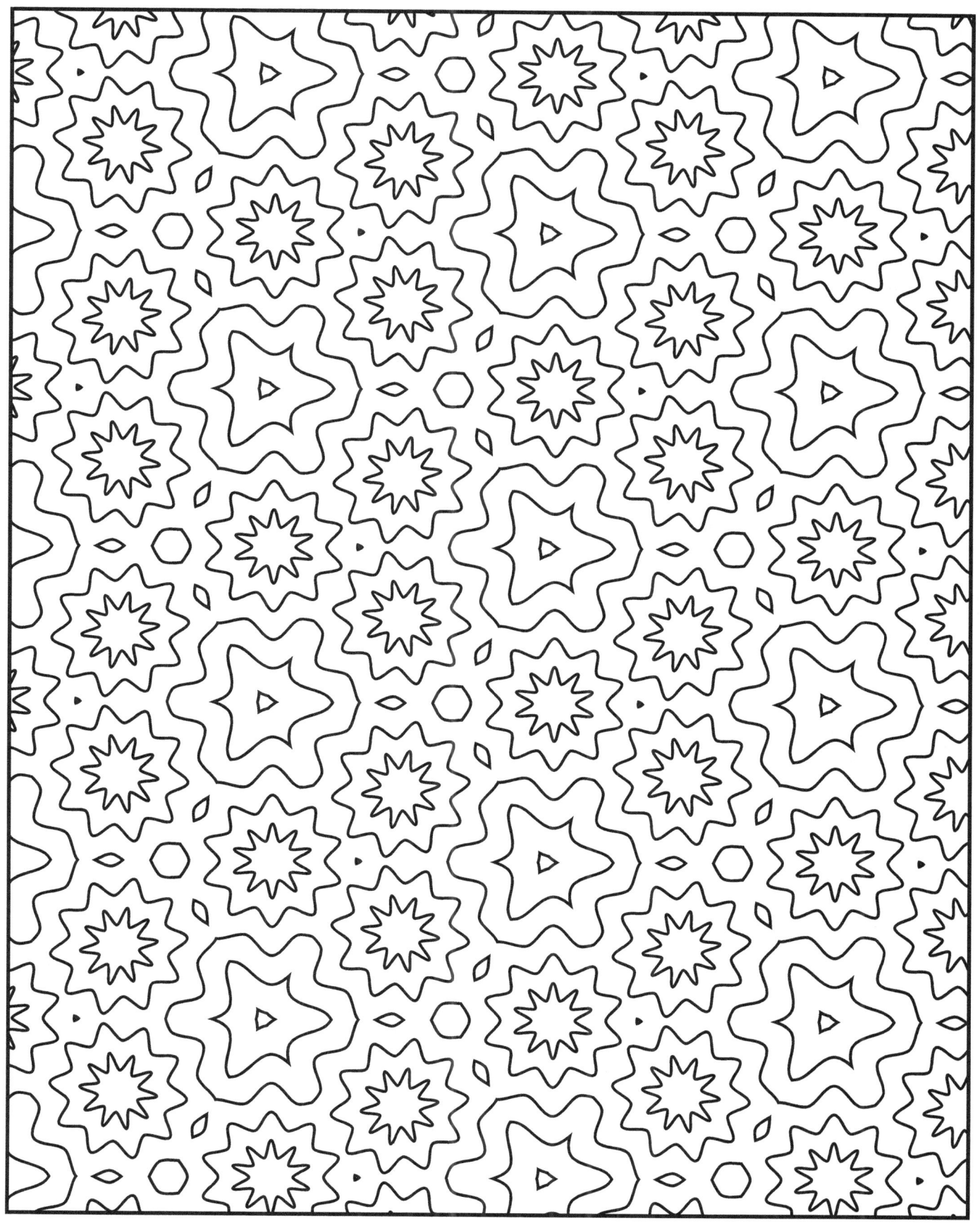

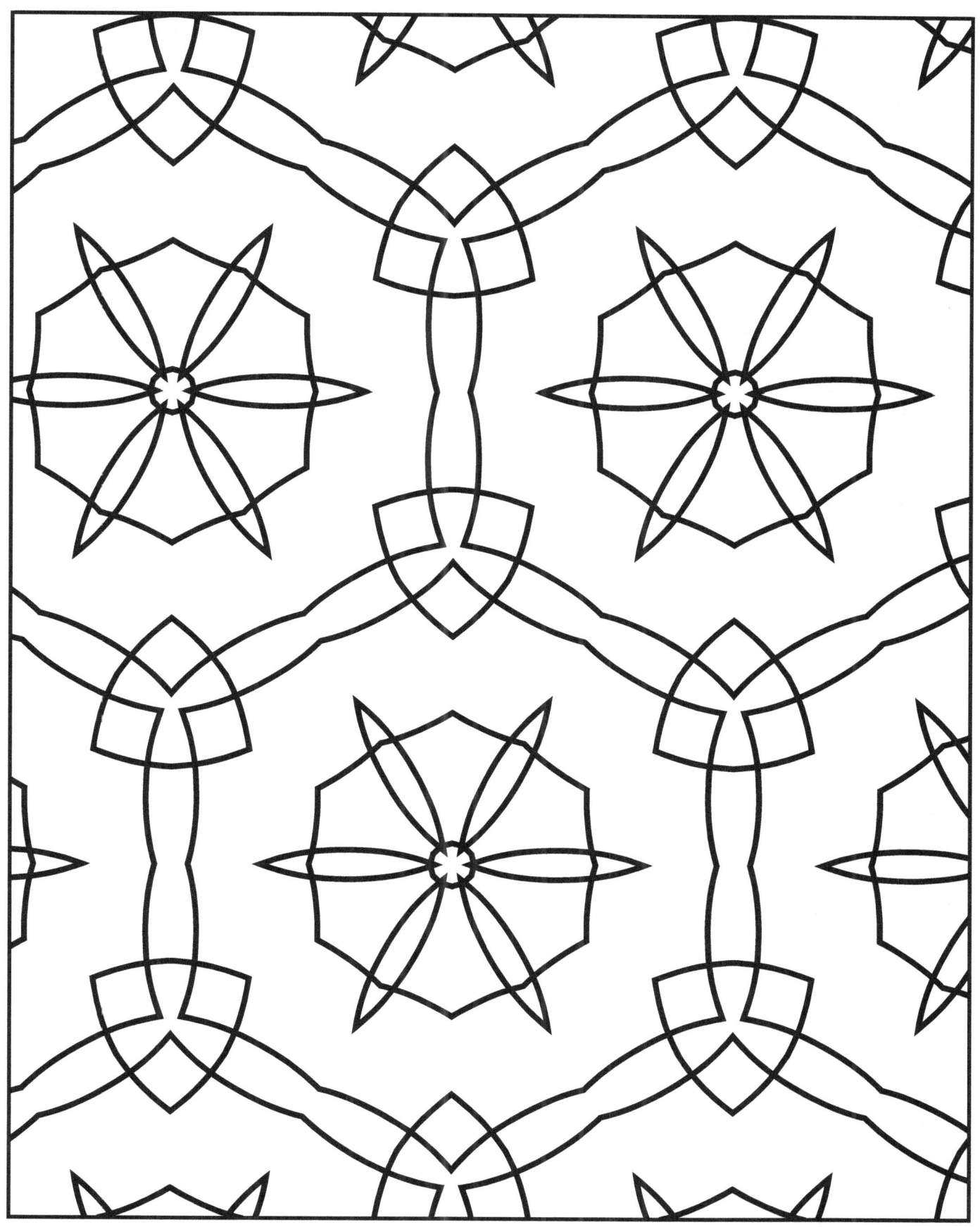

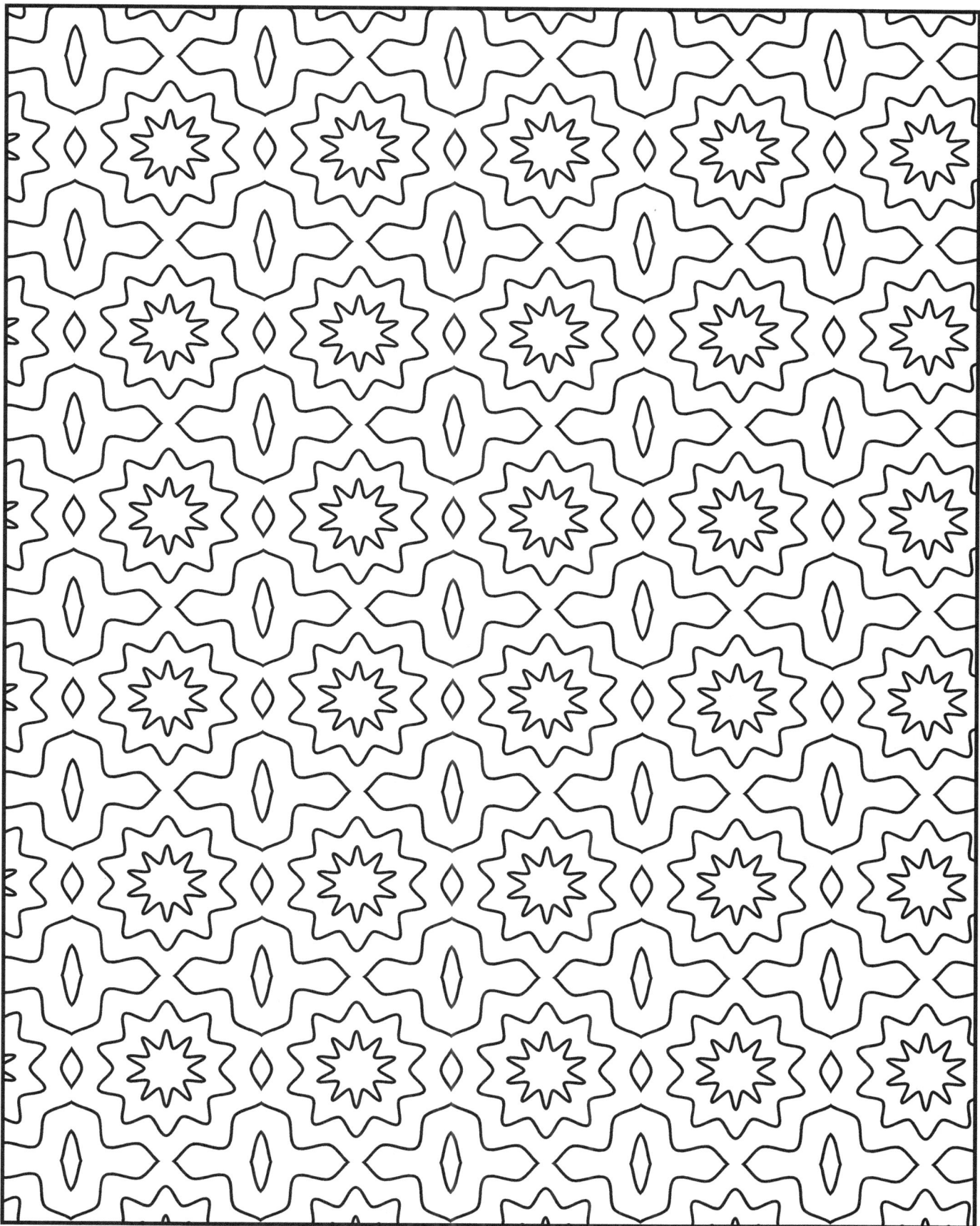

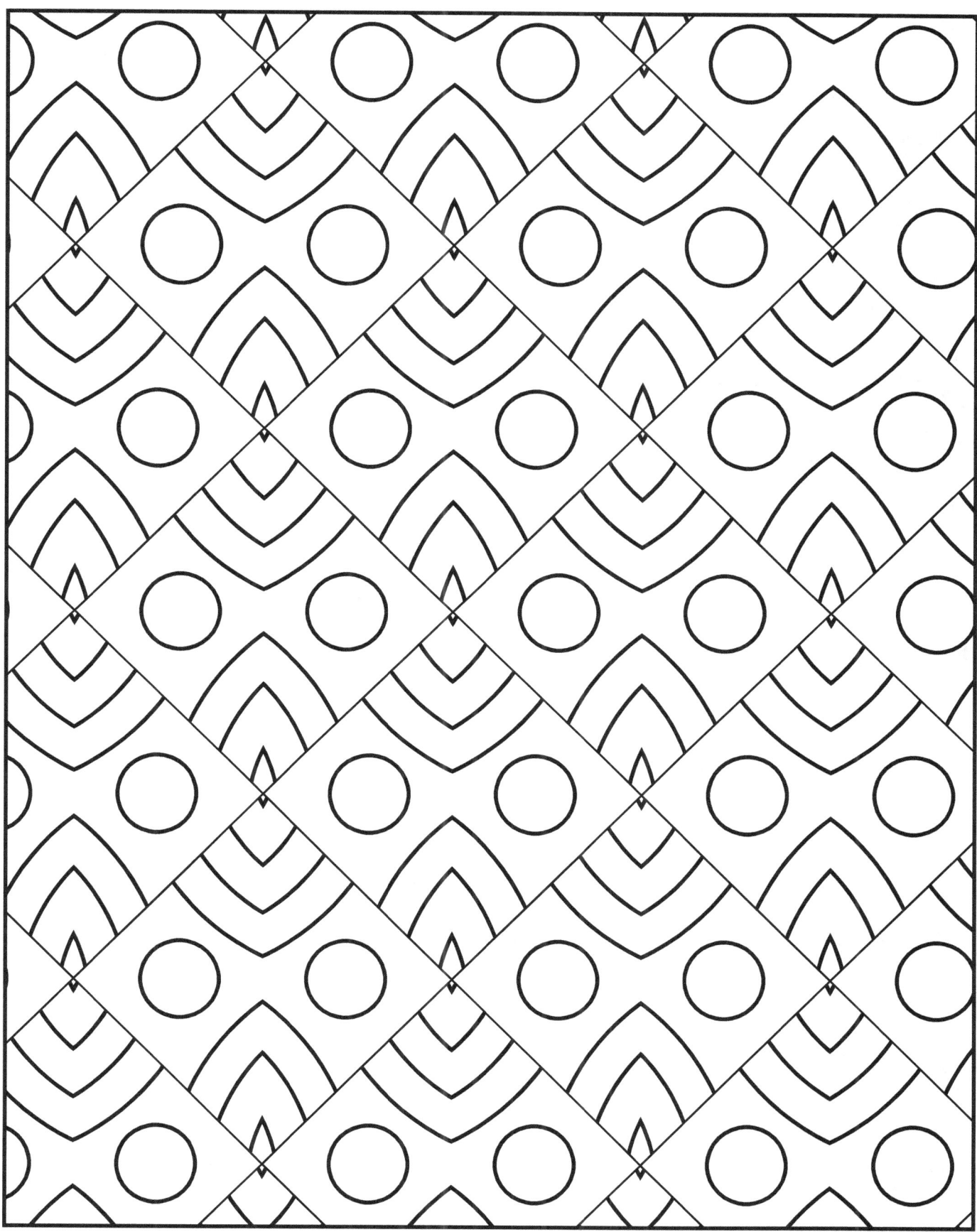

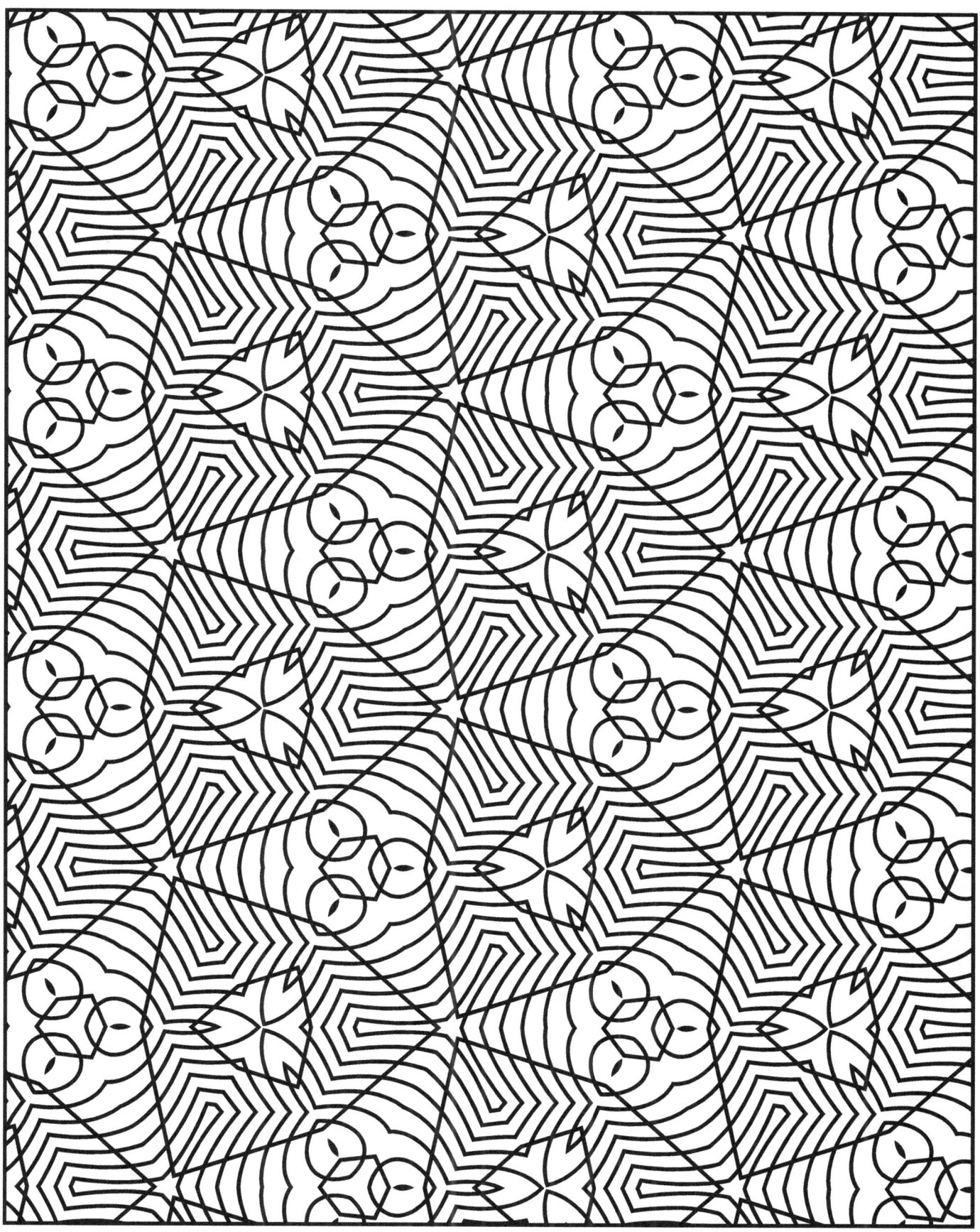

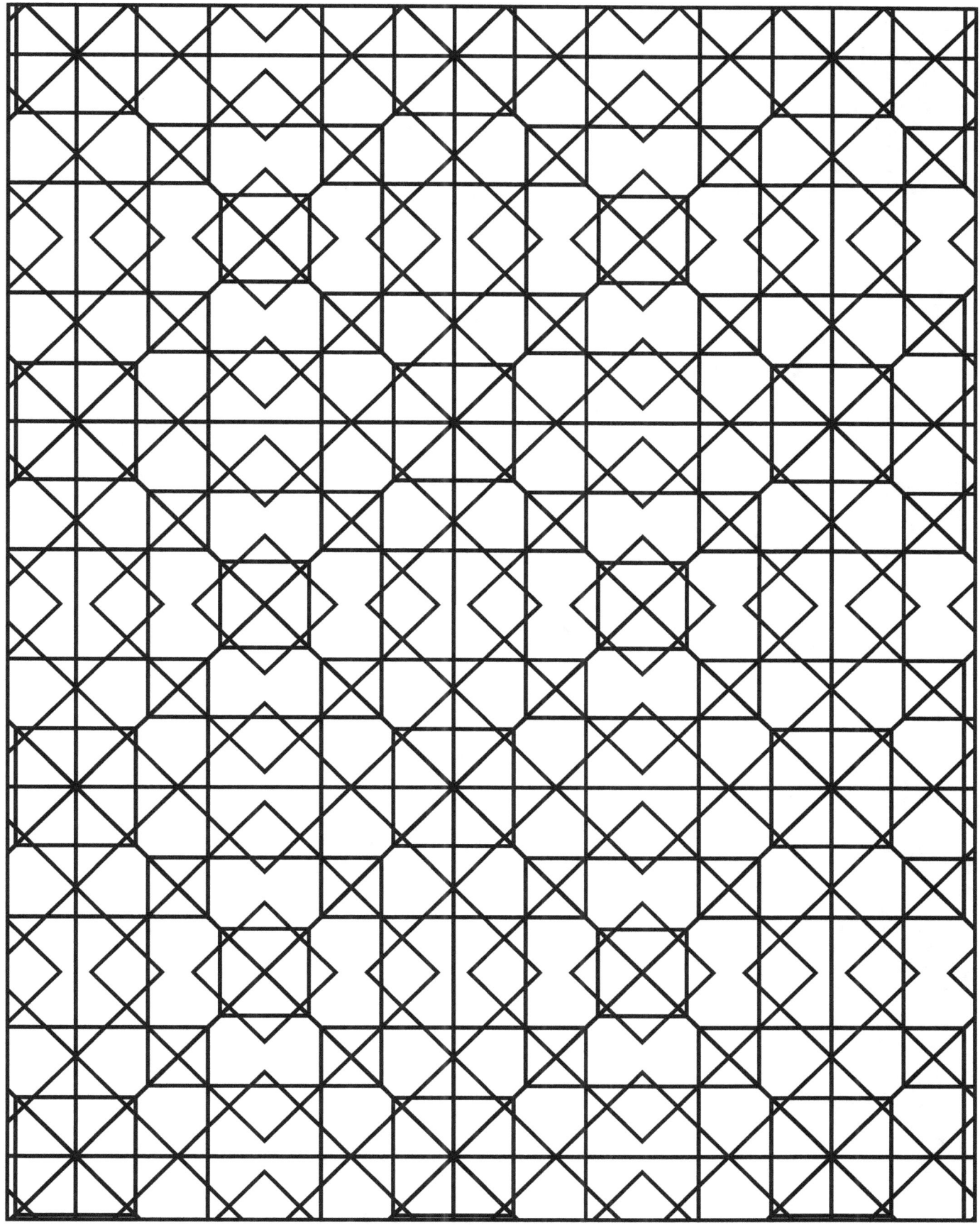

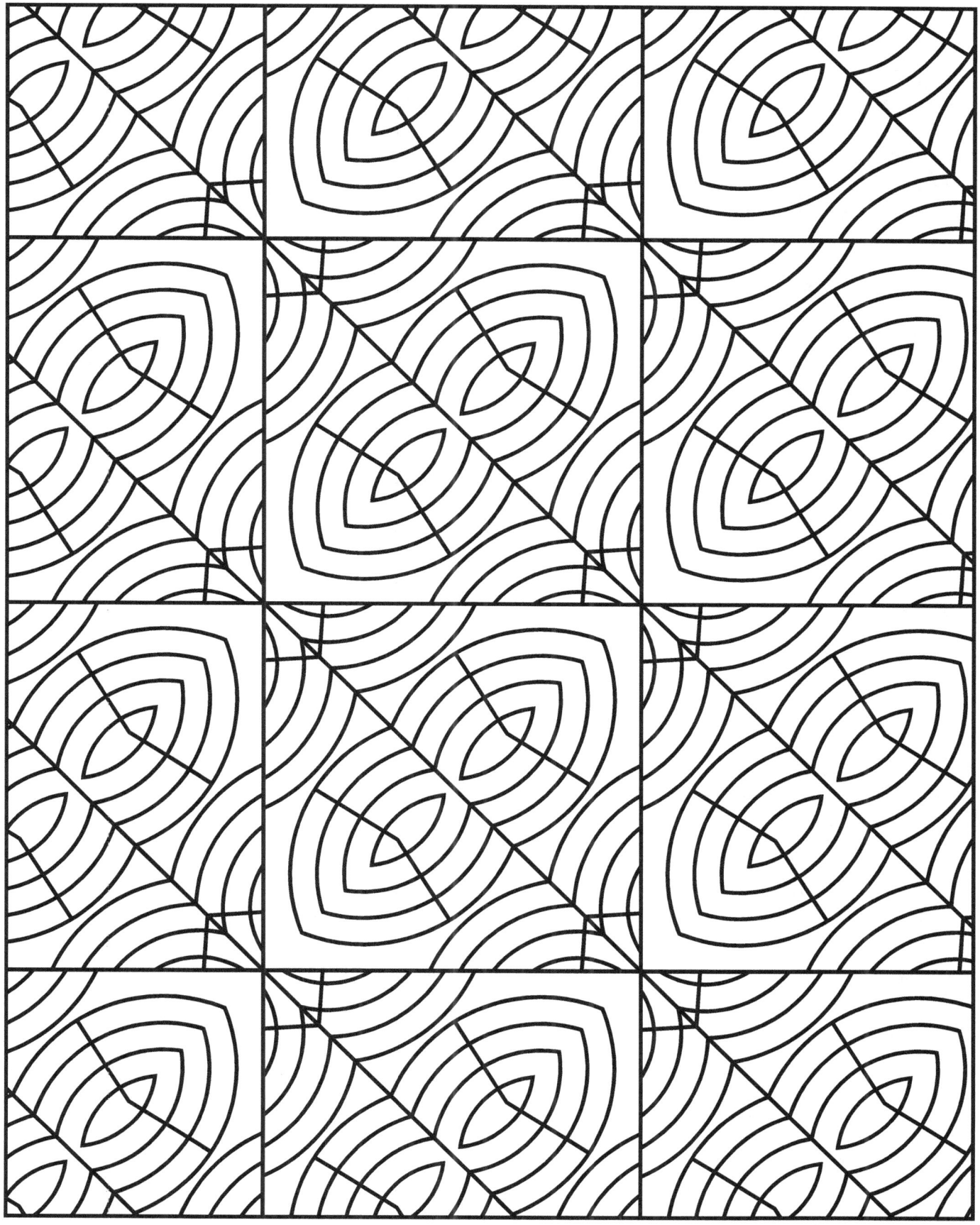

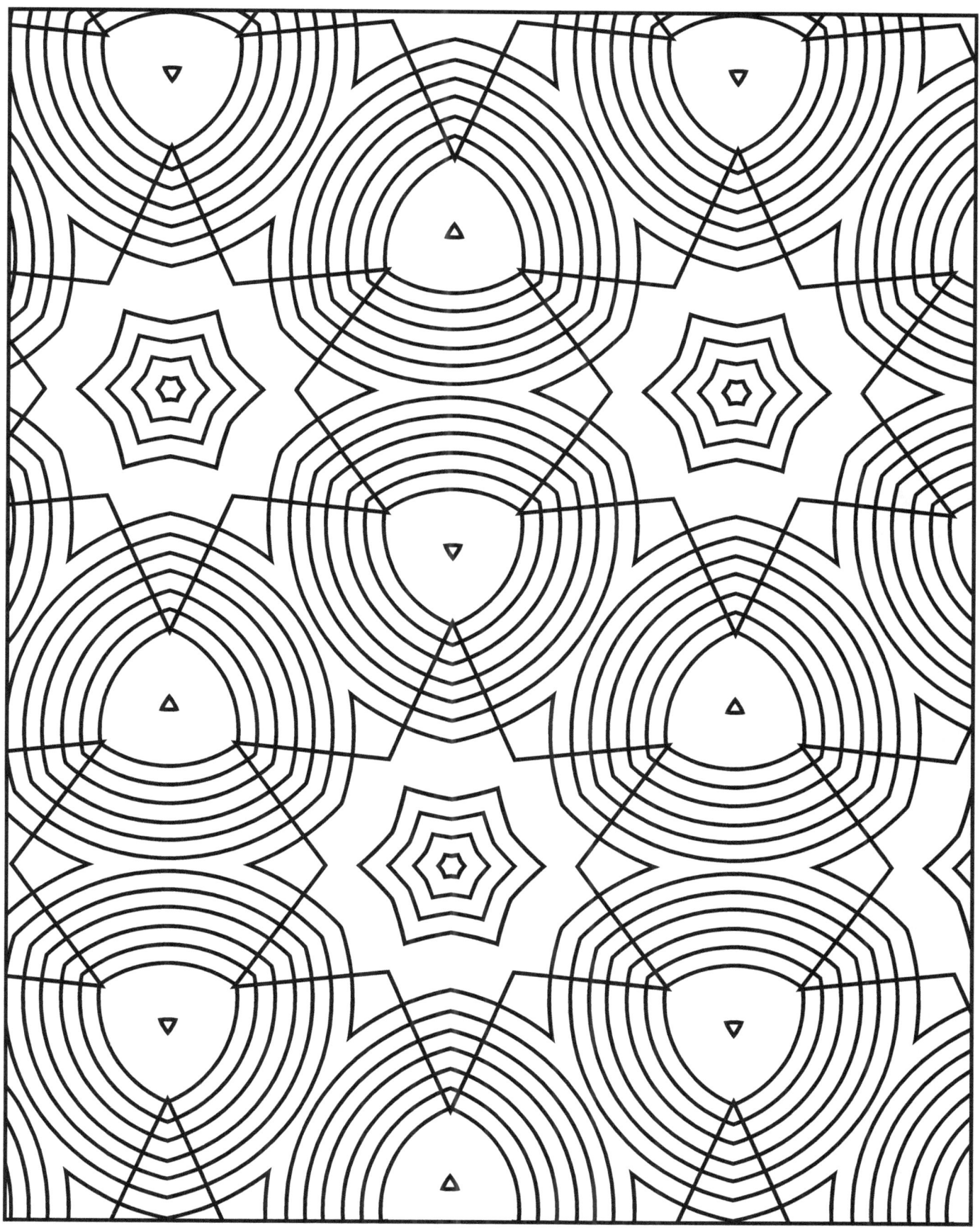

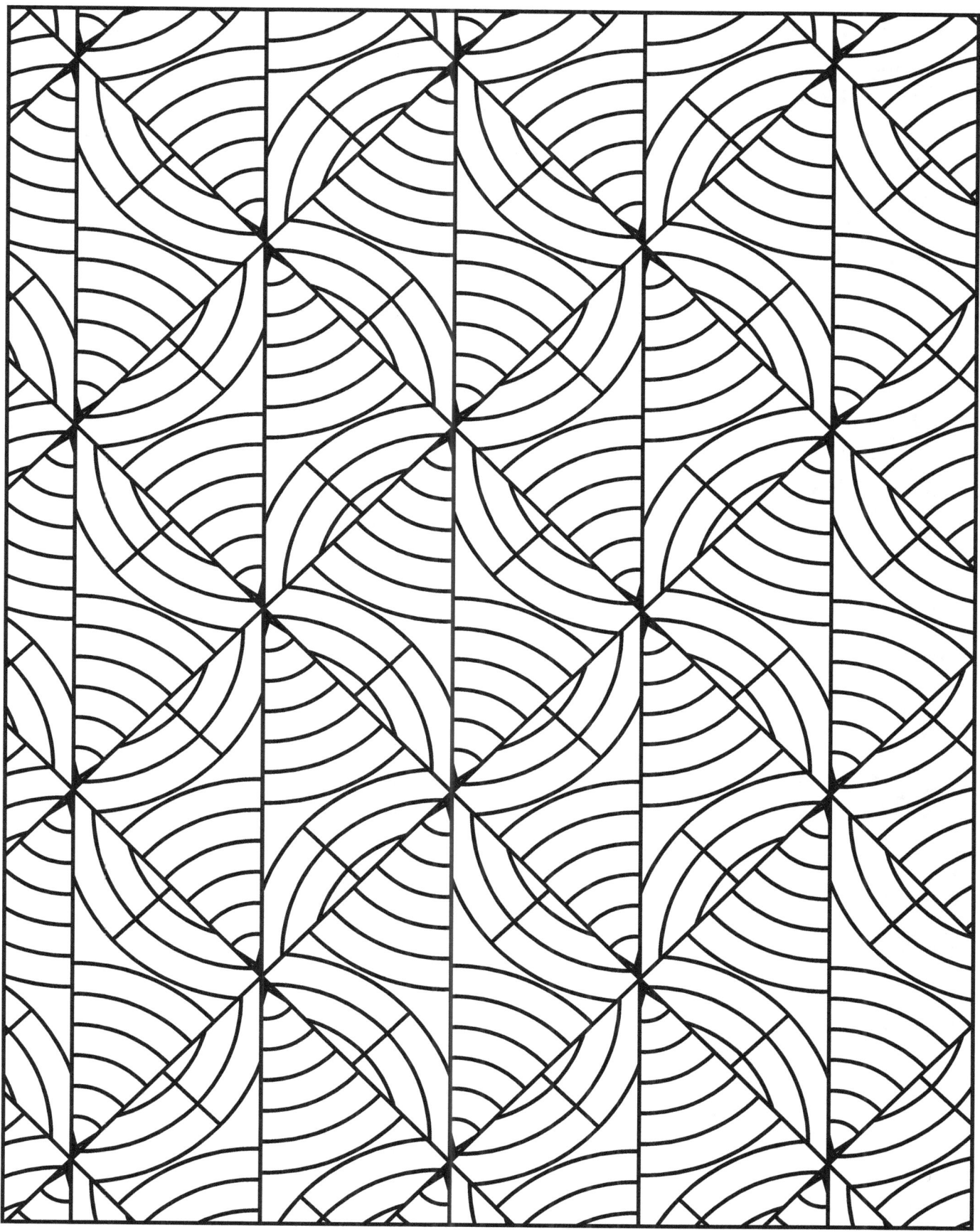

www.ingramcontent.com/pod-product-compliance
Lightning Source LLC
Chambersburg PA
CBHW081201180526

45170CB00006B/2181